30 Cutesie Rabbit Prompts Drawing For Fun And Creativity

This Book Belongs To

Rabbit with Rainbow Background

Rabbit On Surfboard

Cowboy Rabbit

Rabbit with Dirty Chocolaty Mouth

Rabbit With A Basket of Carrots

Rabbit Sky-Diving

Rabbit With Wheel-Barrow Of Easter Eggs

Rabbit Cooking With Spatula

Red-Indian Rabbit

Rabbit In Hot Air Balloon

Rabbit Ninja

Rabbit In Yoga Pose

Rabbit Wearing Party Mask

Ballerina Rabbit

Rabbit Eating Watermelon

Rabbit Sleeping On Crescent Moon

Rabbit wearing Chef's Hat

Rabbit Flying On Balloons

Rabbit Unicorn

Rabbit with Umbrella

Fluffy Bunny With Big Spectacles

Rabbit Wearing A Crown

Rabbit In Polka Dot Onesie

Rabbit Eating Ice-Cream

Rabbit Wearing Warm Woolen Hat

Rabbit Jumping Through Hoola Hoop

Rabbit with Big Ribbon On Head

Rabbit With A Rose

Rabbit And Tortoise

Super Hero Rabbit
